O Holy Night

A MEDITATIVE CHRISTMAS COLORING BOOK

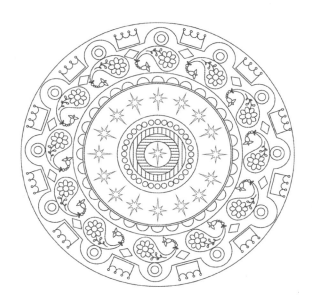

A Note from the Illustrator:

As I created the first few illustrations for this book, I considered adding a little signature to personalize it. I quickly realized the image of the cross symbolizes the purpose for these books; without the cross we have nothing. I've been incredibly blessed in my life and the opportunity to create visual scriptures has been a wonderful way to give the glory back to God. I hope you enjoy finding the small cross I incorporated into each illustration. To me, it's a literal example of "seek and ye shall find." If we look for the good, the joyful, and the happiness available to us through the grace of Christ, we will find it.

—*Pam*

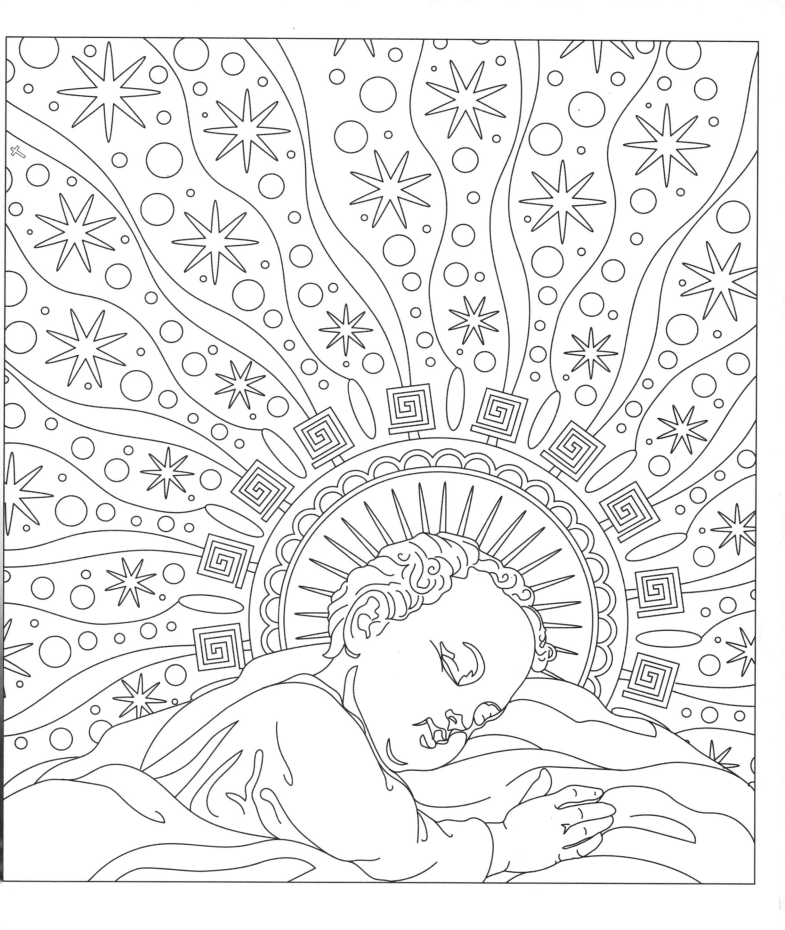

O come, let us adore him, Christ the Lord.
"O Come All Ye Faithful"

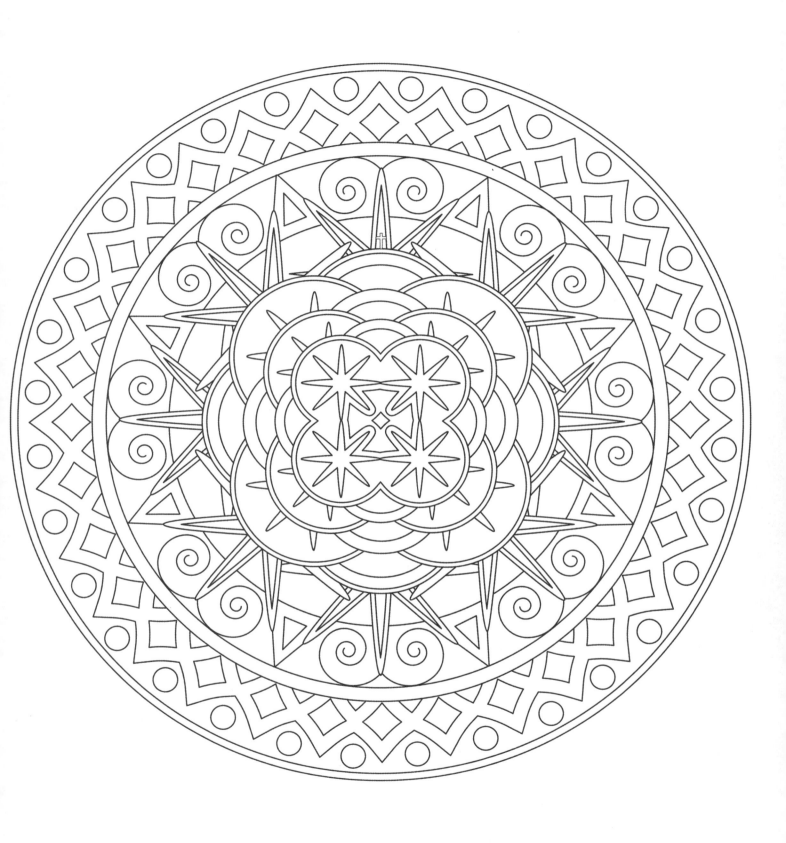

...they shall call his name Emmanuel, which being interpreted is, God with us.

Matthew 2:23

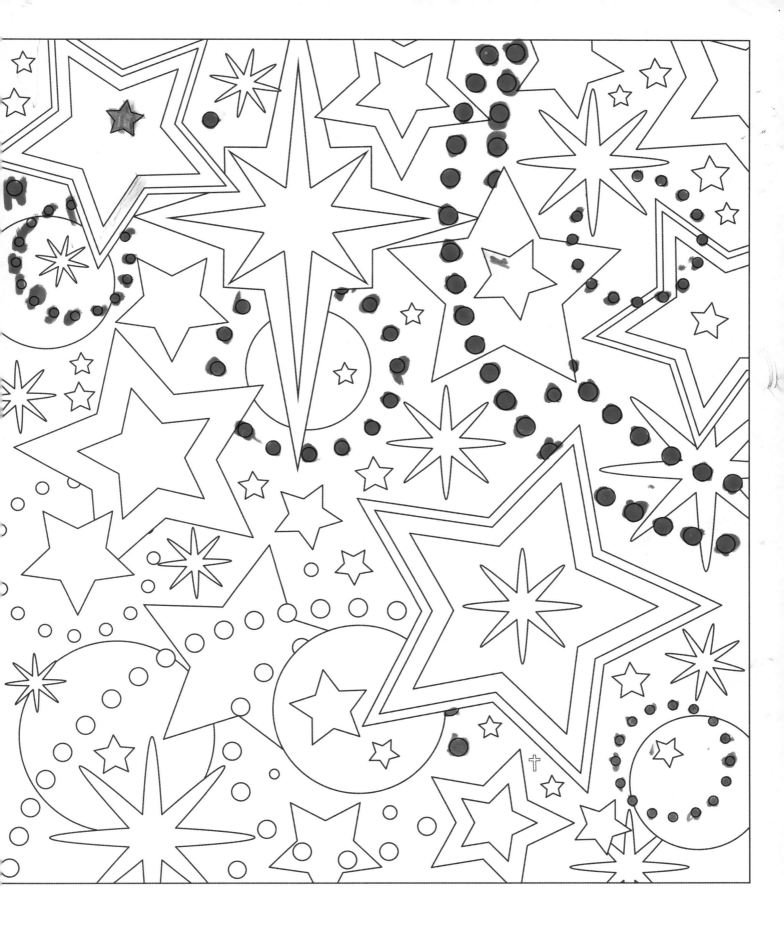

O Holy Night, the stars are brightly shining...
"O Holy Night"

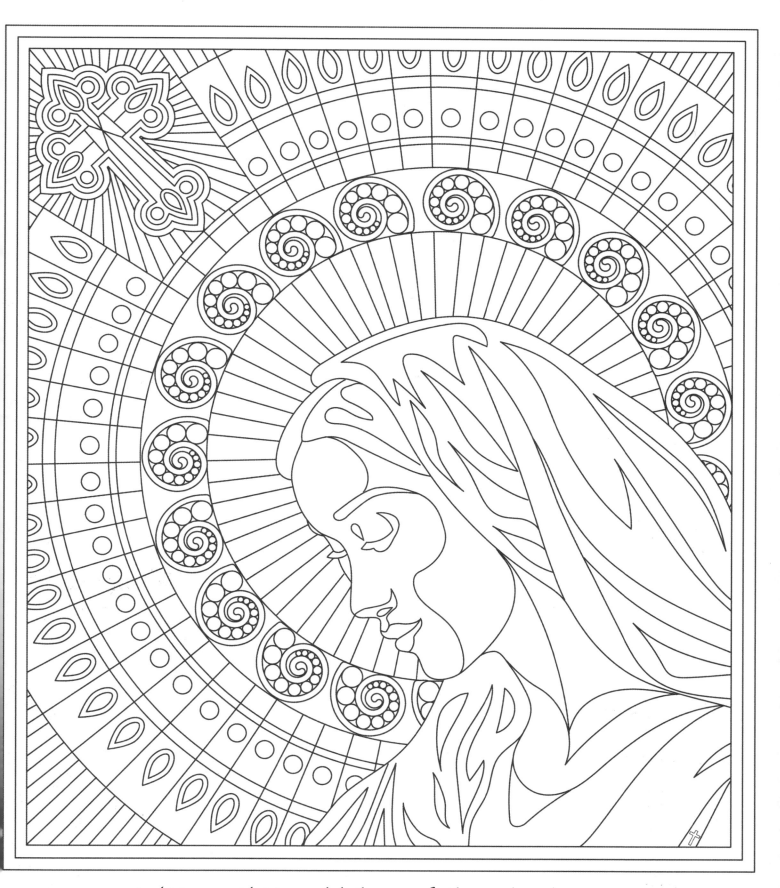

And Mary said, My soul doth magnify the Lord, and my spirit hath rejoiced in God my Saviour.

Luke 1:46-47

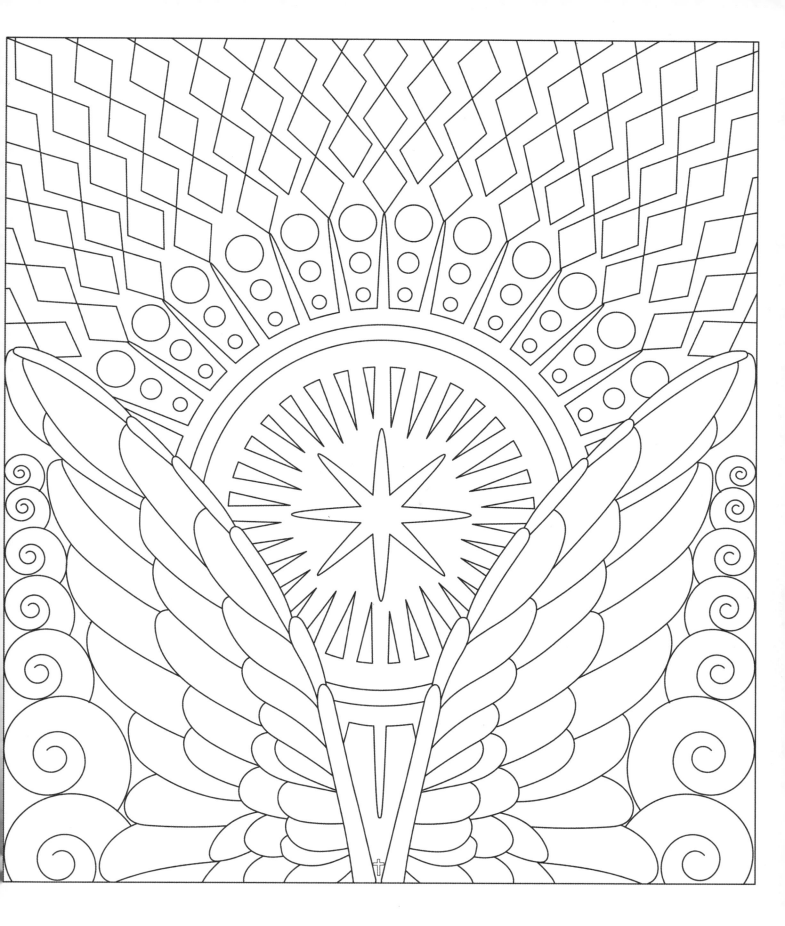

And suddenly there was with the angel a multitude of the heavenly host praising God...
Luke 2:13

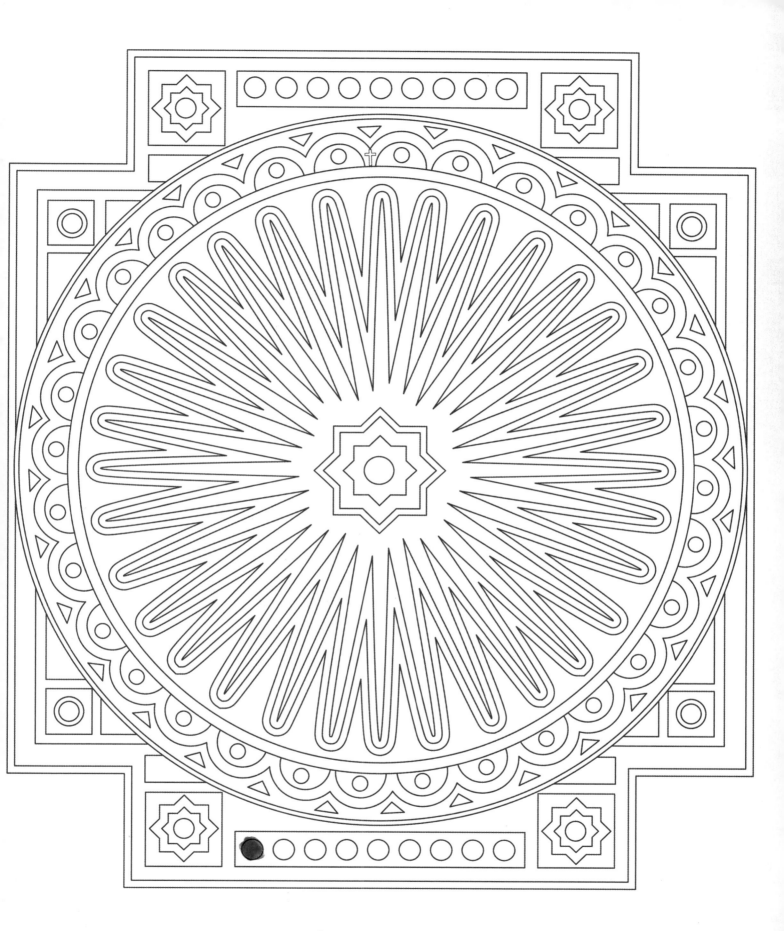

Born to raise the sons of Earth, born to give them second birth...
"Hark! The Herald Angels Sing"

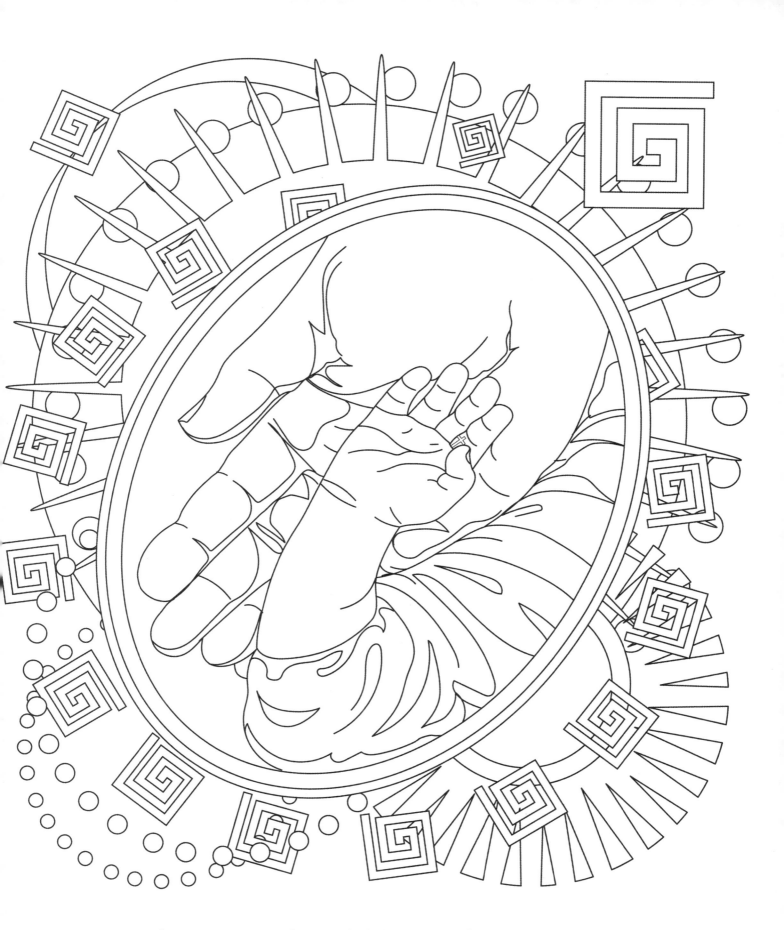

Round yon virgin, mother and child, Holy infant, tender and mild...
"Silent Night"

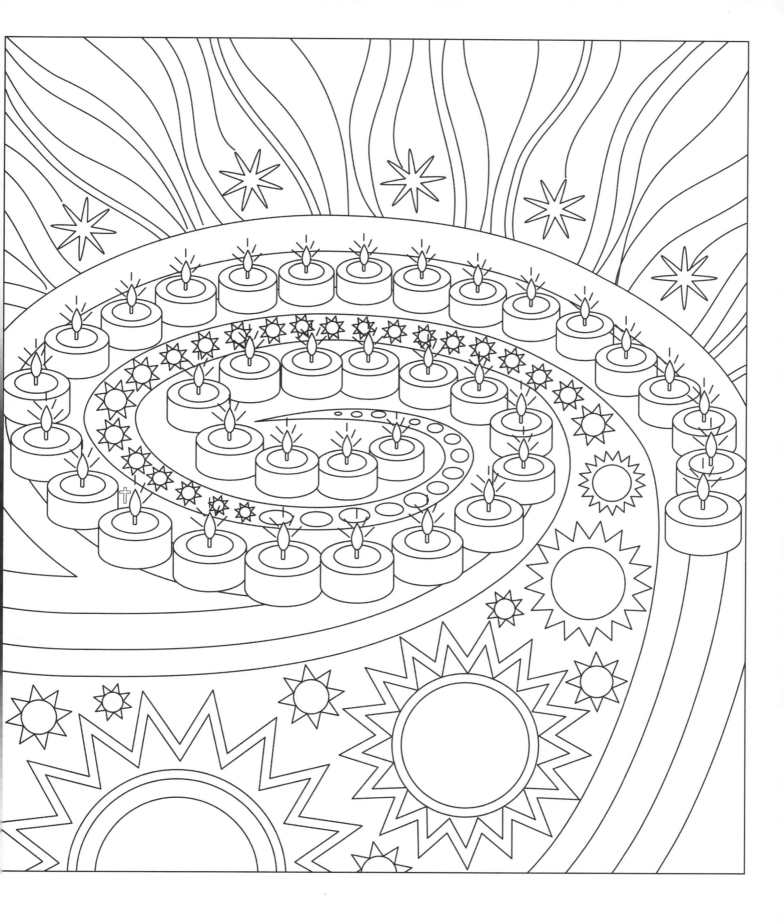

Son of God, love's pure light...
"Silent Night"

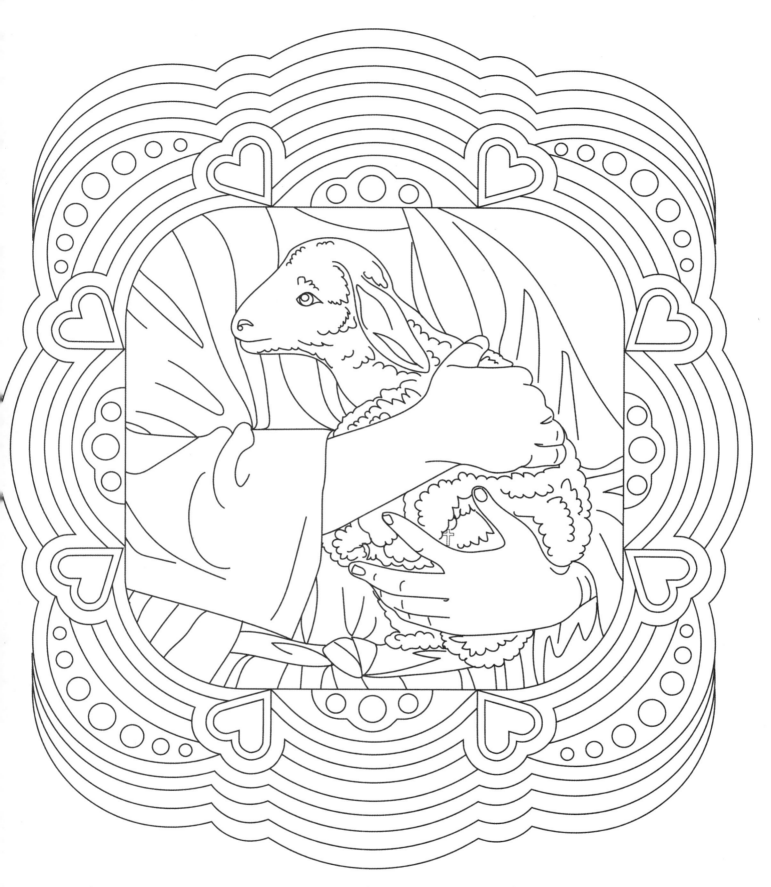

What can I give Him, poor as I am? If I were a shepherd, I would bring a lamb;
If I were a Wise Man, I would do my part; Yet what can I give Him: give my heart.
"In the Bleak Midwinter"

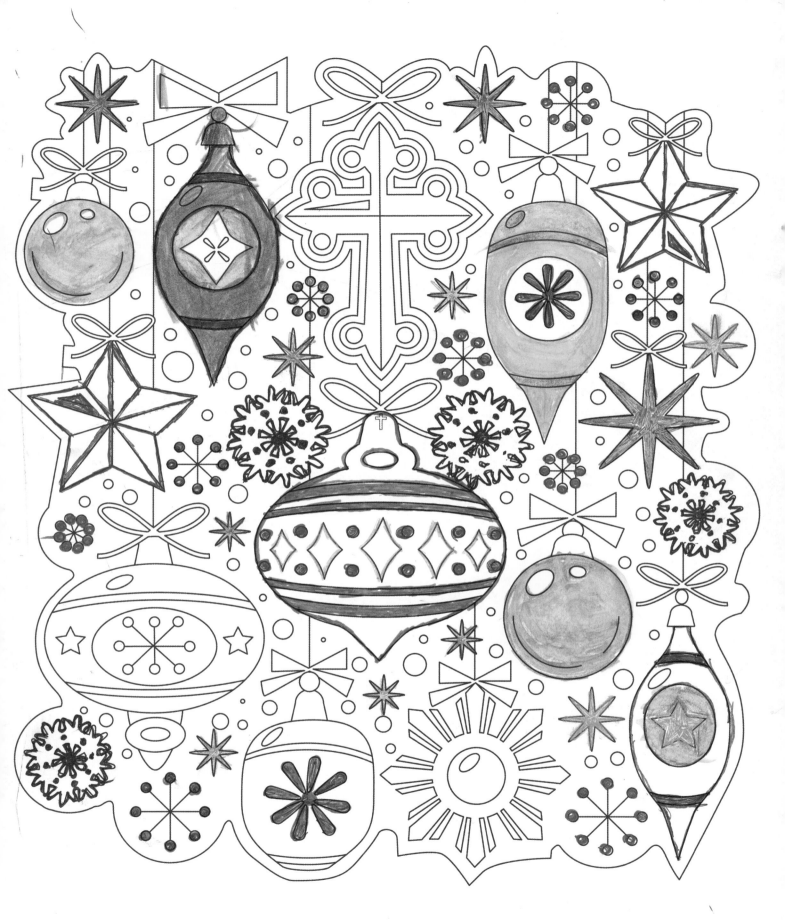

Rejoice! Rejoice! Emmanuel Shall come to thee, O Israel.

"O Come, O Come, Emmanuel"

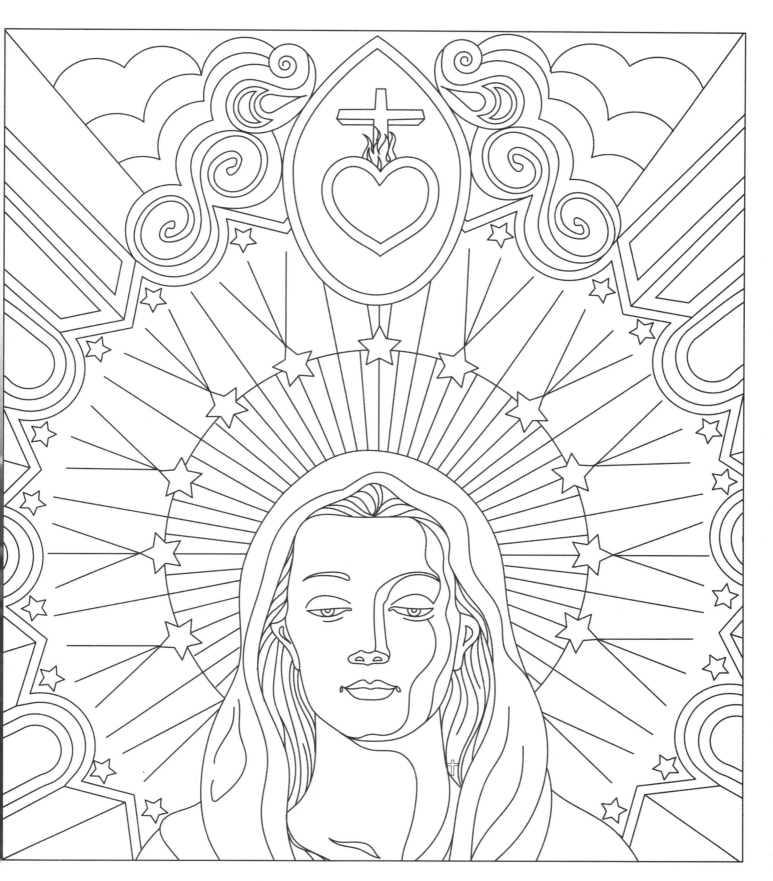

Joseph, thou son of David, fear not to take unto thee Mary thy wife:
for that which is conceived in her is of the Holy Ghost.

Matthew 1:20

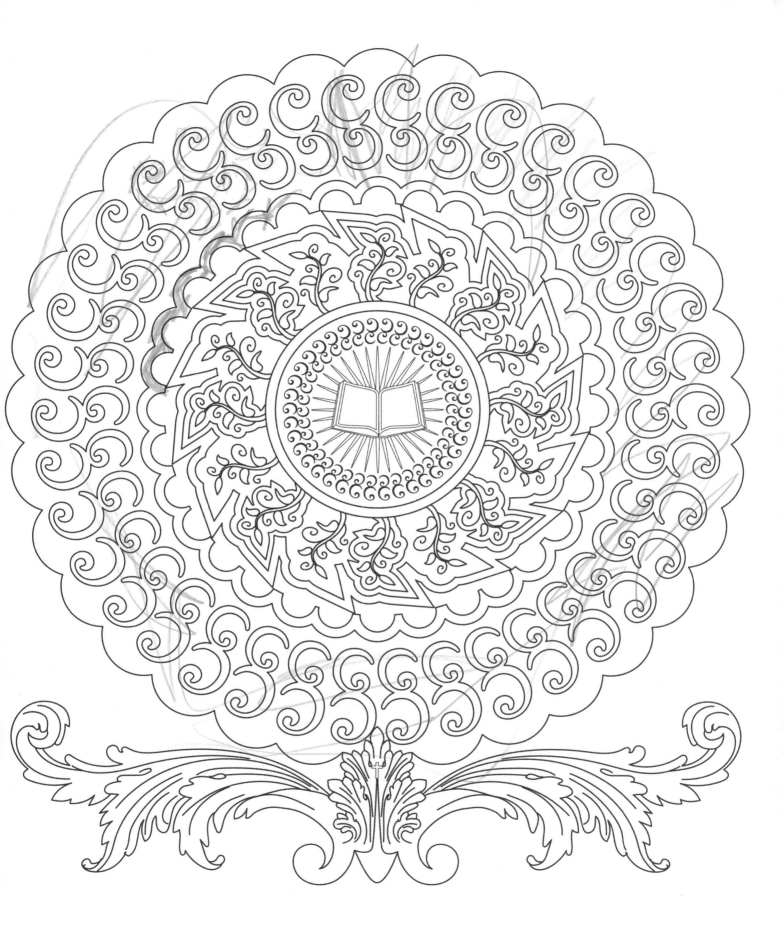

Word of the Father, now in flesh appearing...
"O Come All Ye Faithful"

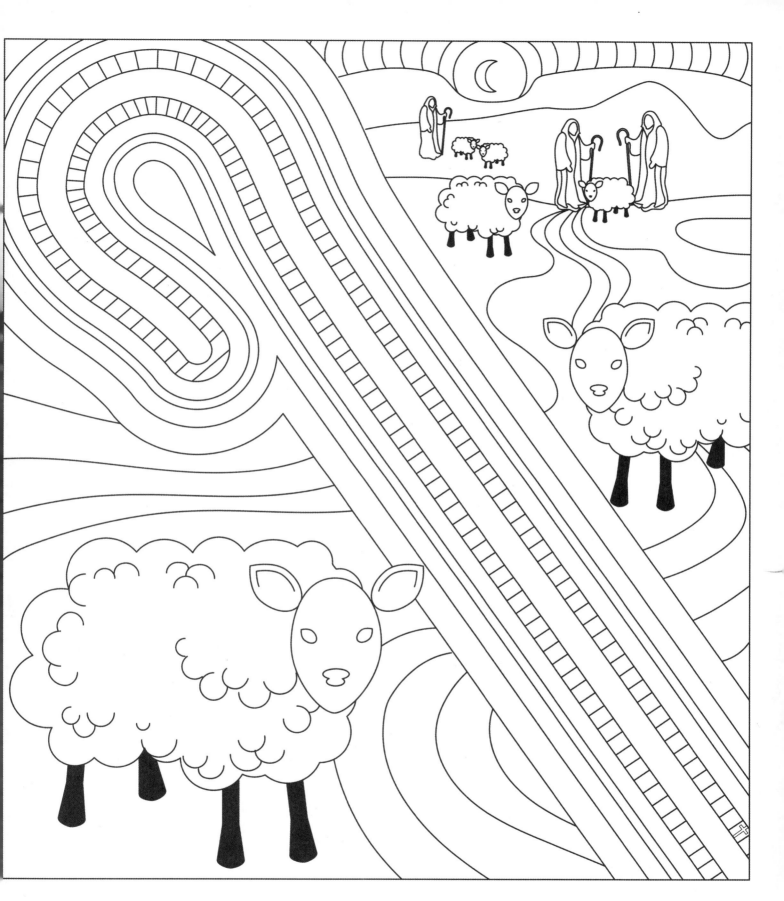

And there were in the same country shepherds abiding in the field, keeping watch over their flock by night.

Luke 2:8

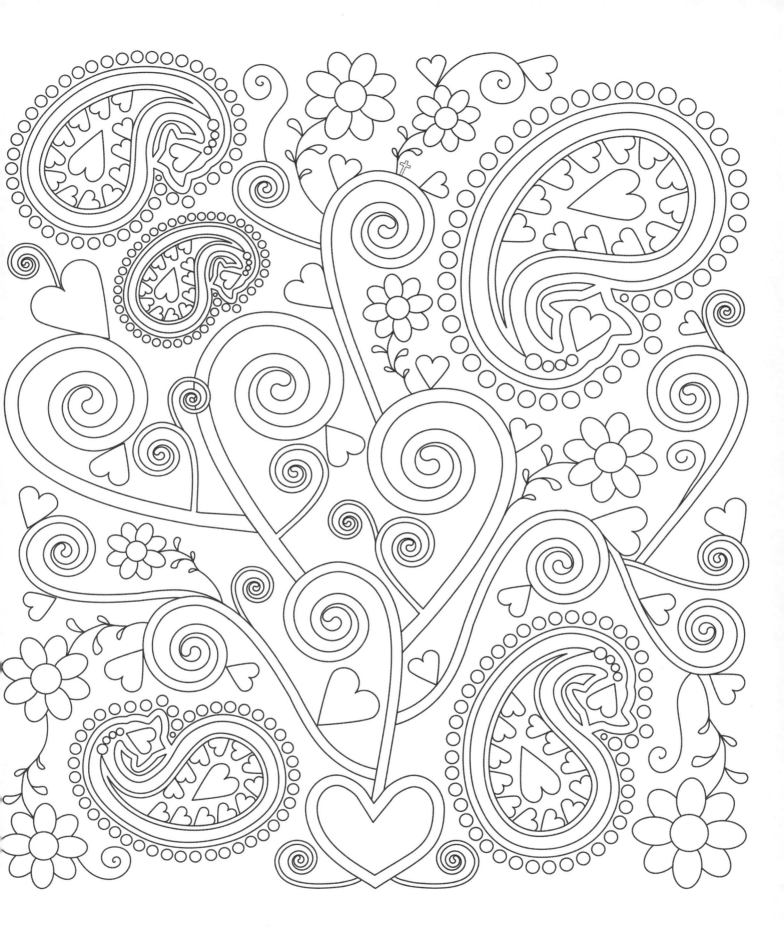

Let every heart prepare Him room, And Heaven and nature sing...
"Joy to the World"

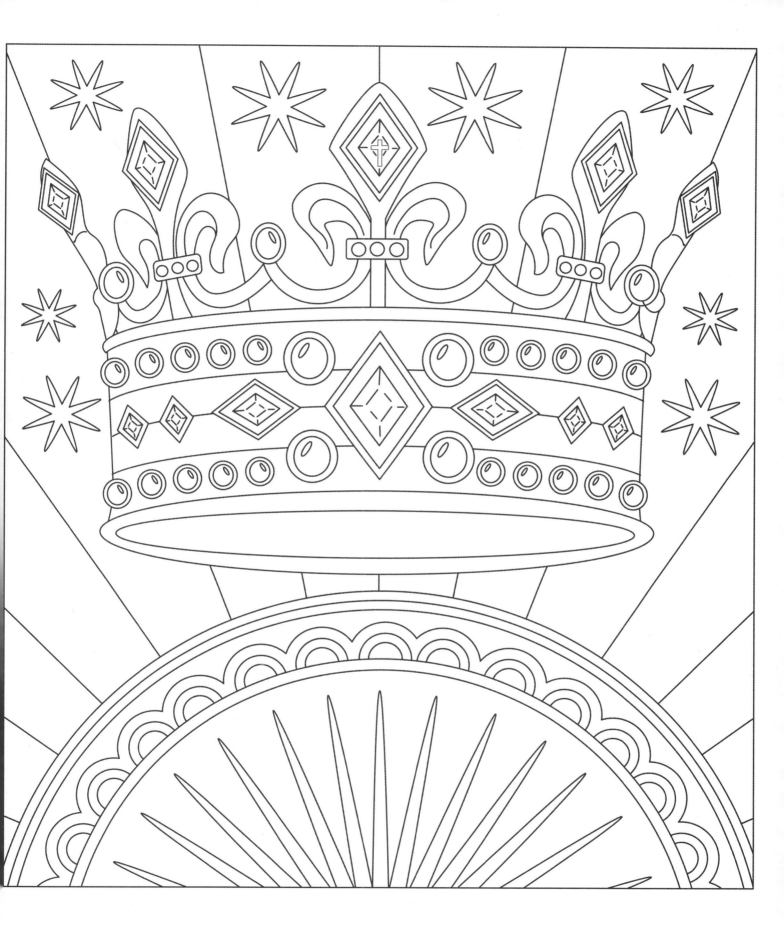

Peace on the earth, good will to men From Heaven's all gracious King!
"It Came Upon the Midnight Clear"

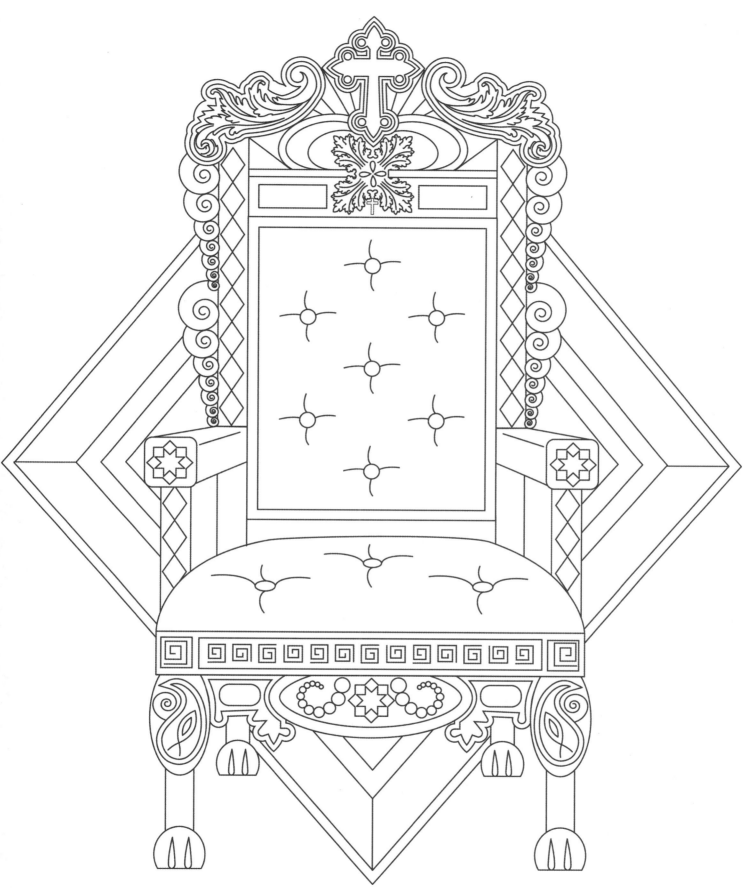

...He will be great, and will be called the Son of the Highest; and the Lord God will give Him the throne of His father David.

Luke 1:32

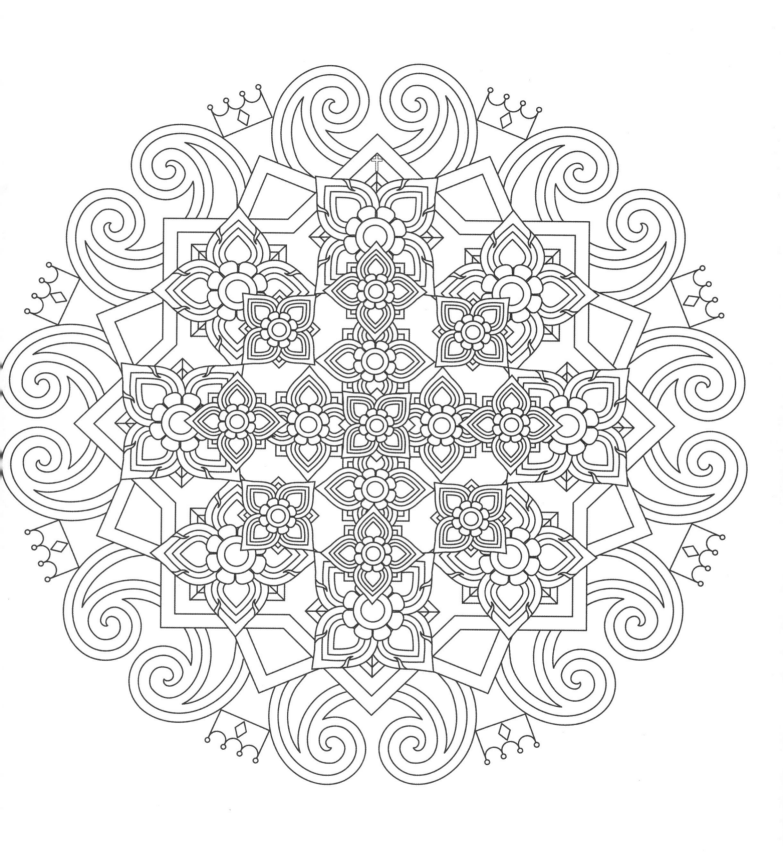

Long lay the world in sin and error pining, 'til He appeared and the soul felt its worth.
"O Holy Night"

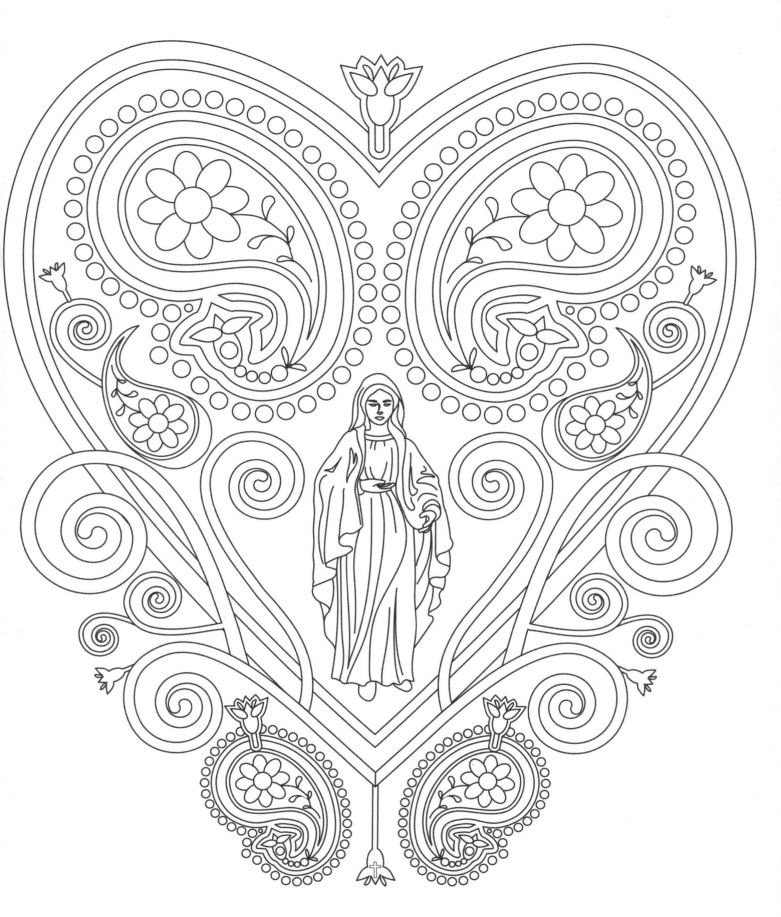

Mary kept all these things, and pondered them in her heart.
Luke 2:19

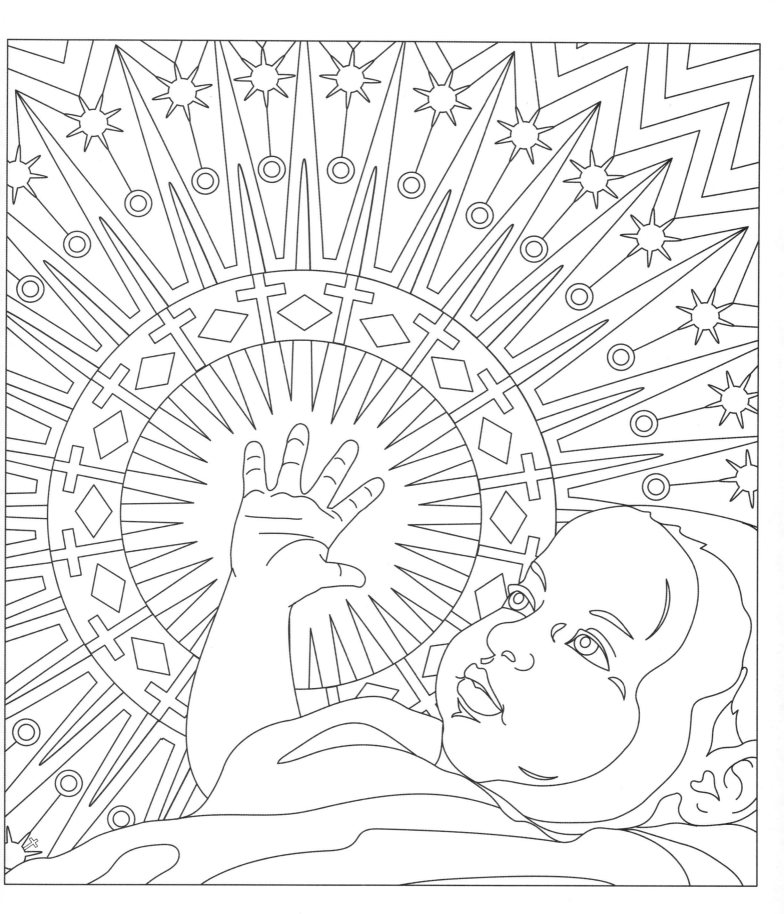

Behold, this child is set for the fall and rising again of many
Luke 2:33

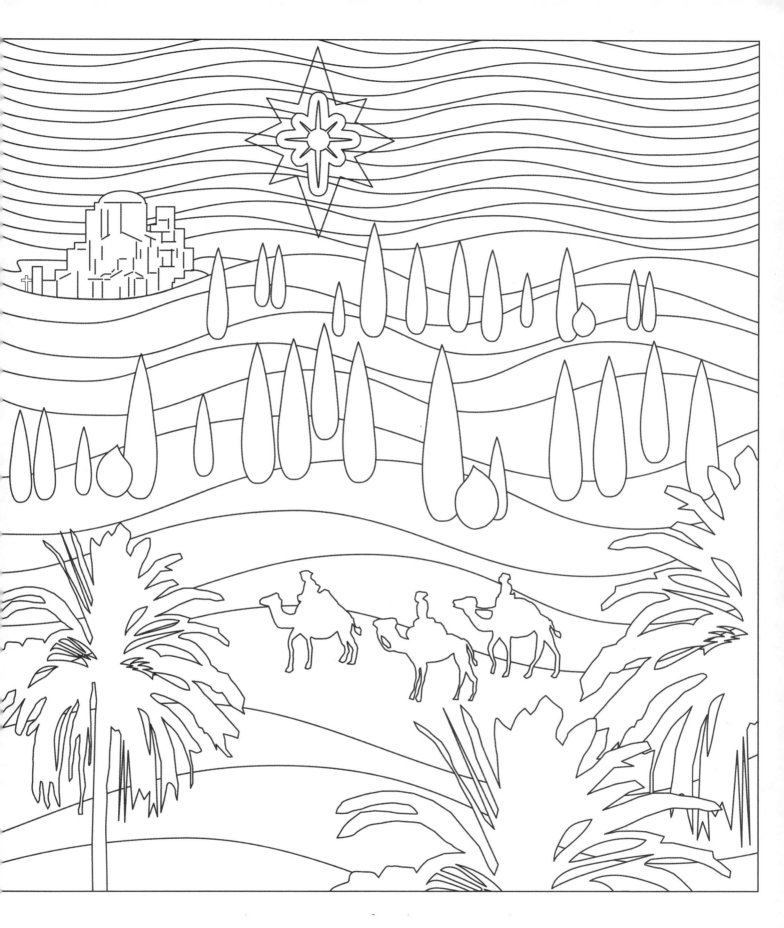

...there came wise men from the east to Jerusalem.
Matthew 2:1

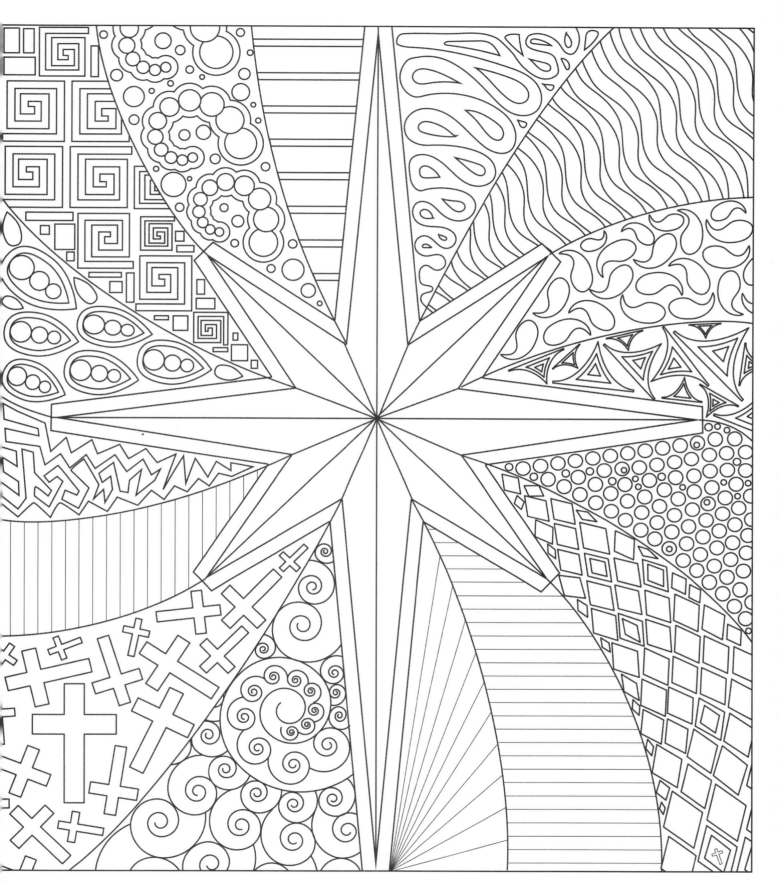

...and, lo, the star, which they saw in the east, went before them, till it came and stood over where the young child was.

Matthew 2:9

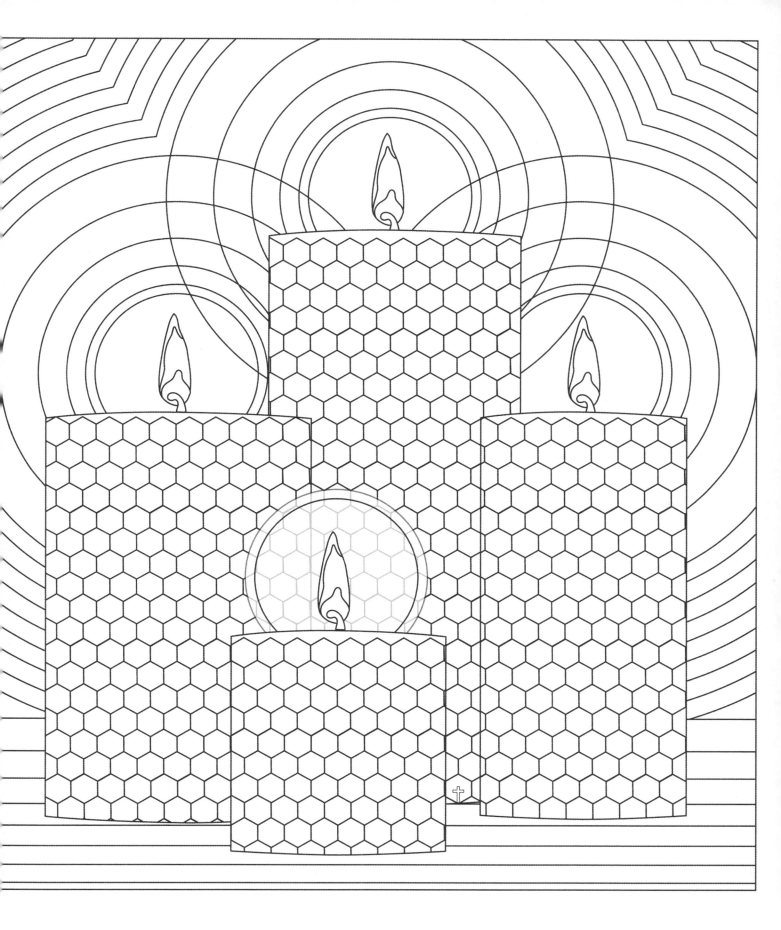

Silent Night, holy night, All is calm, all is bright...
"Silent Night"

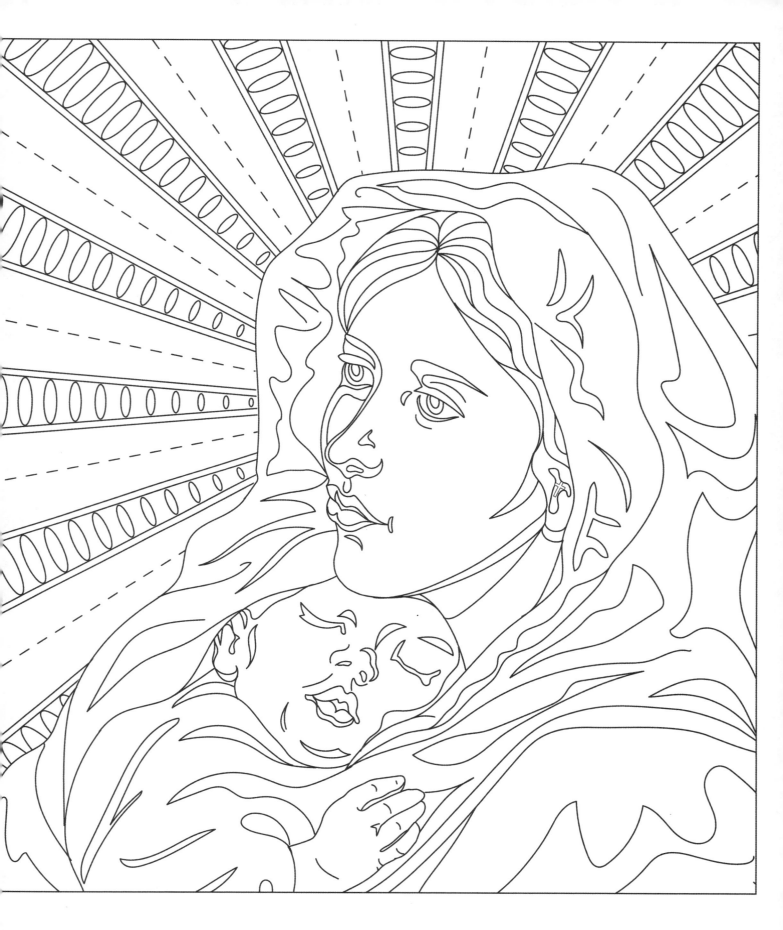

Ah! Ah! beautiful is the Mother! Ah! Ah! beautiful is her child.
"Bring A Torch, Jeannette, Isabella"

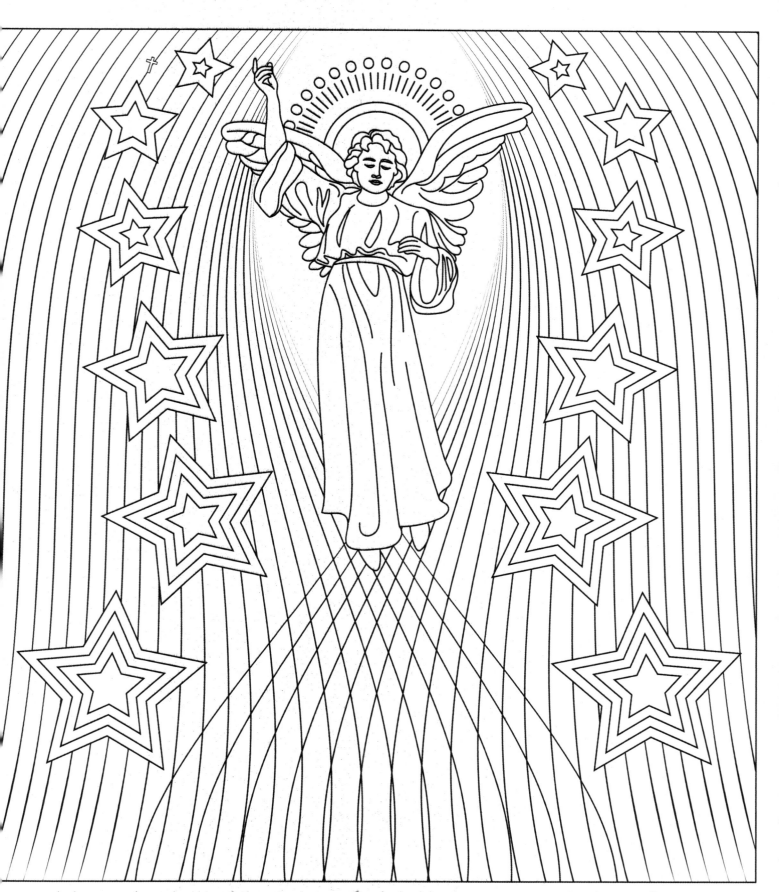

And the angel said unto them, Fear not: for, behold, I bring you good tidings of great joy,
which shall be to all people.

Luke 2:10

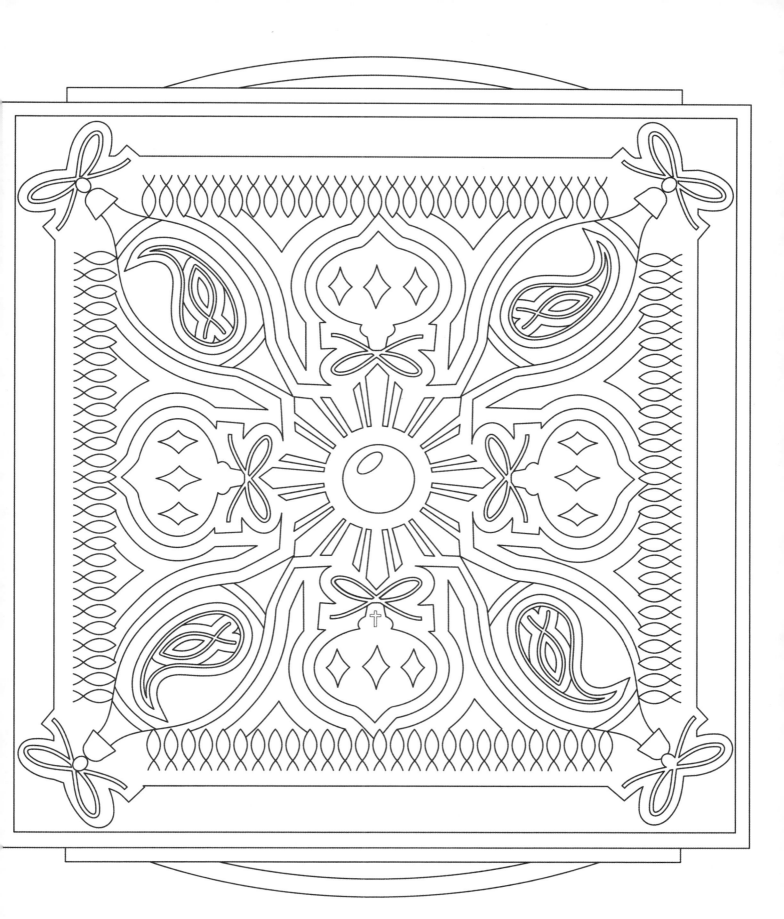

Remember, Christ, our Saviour, Was born on Christmas day...
"God Rest Ye Merry Gentlemen"

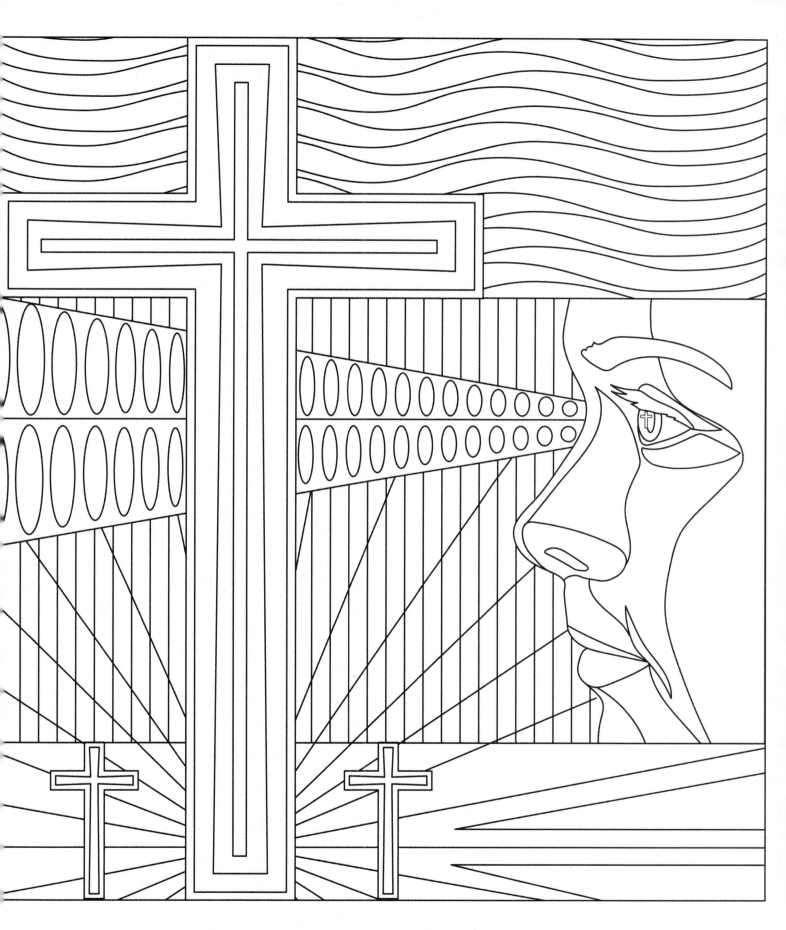

For with God nothing shall be impossible.
Luke 1:37

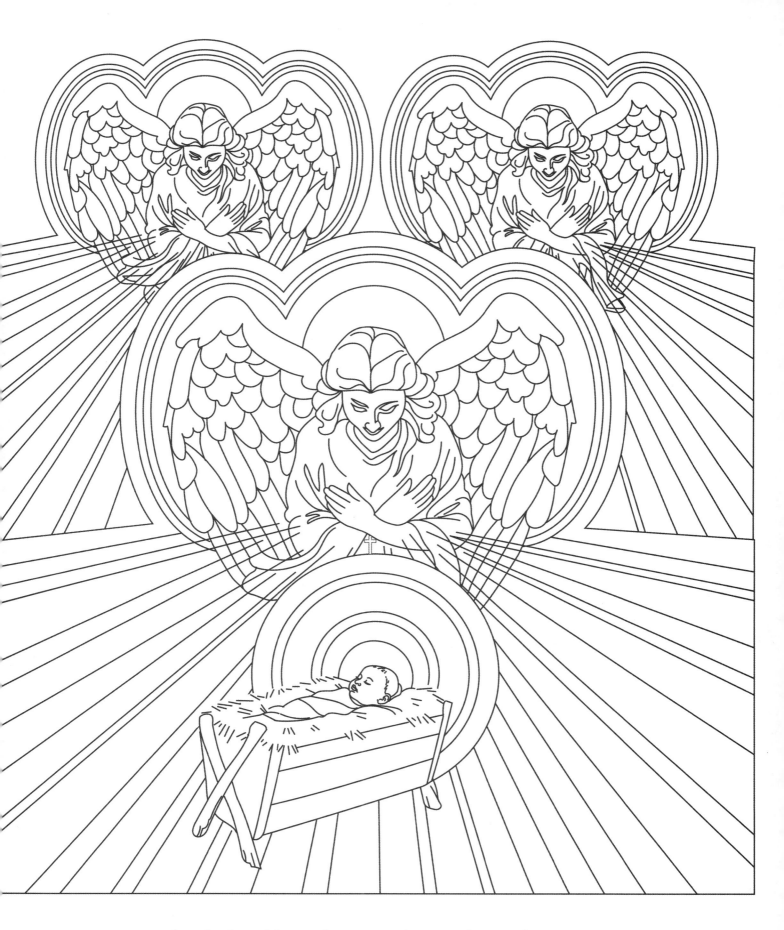

Hark! The herald angels sing, "Glory to the newborn King."
"Hark! The Herald Angels Sing"

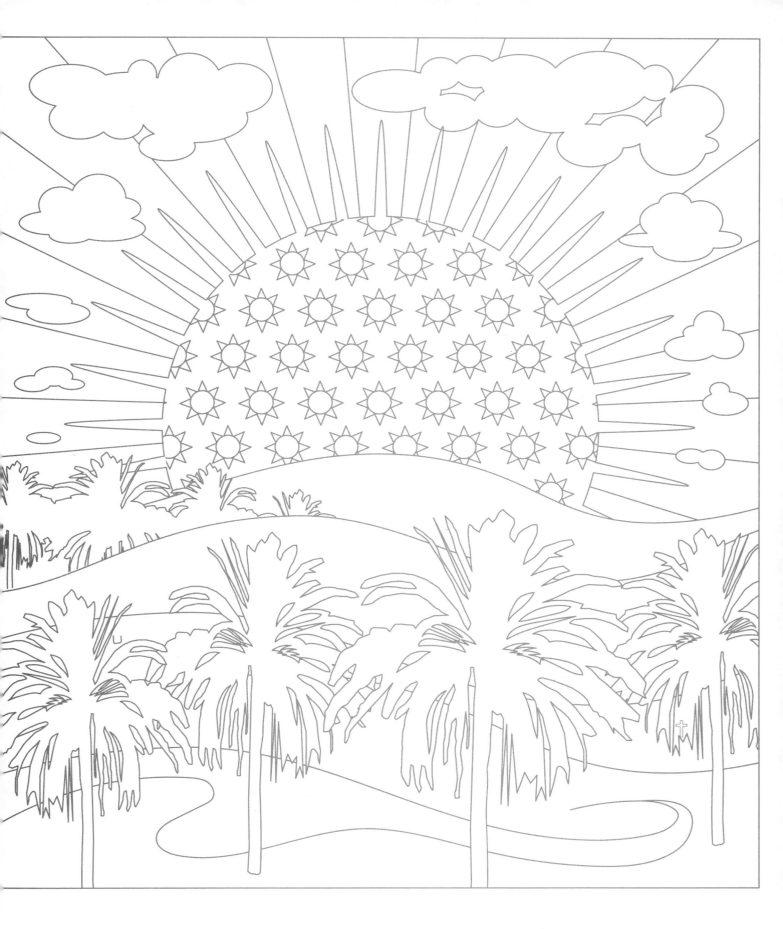

A thrill of hope, the weary world rejoices, For yonder breaks a new and glorious morn.
"O Holy Night"

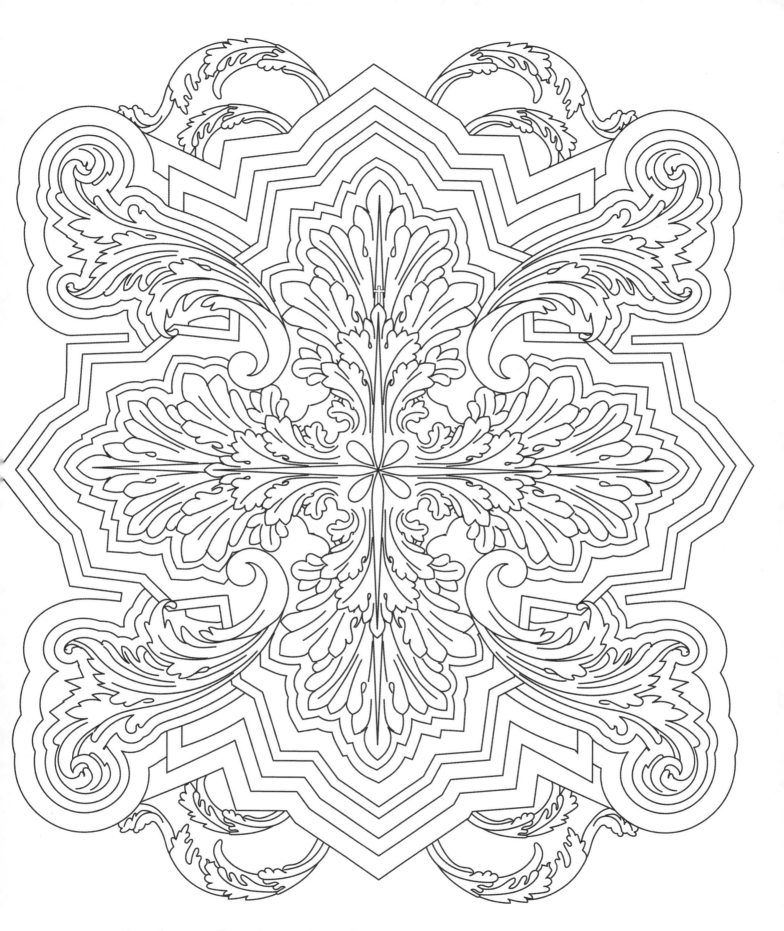

Then let us all with one accord, sing praises to our Heavenly Lord...
"The First Noel"

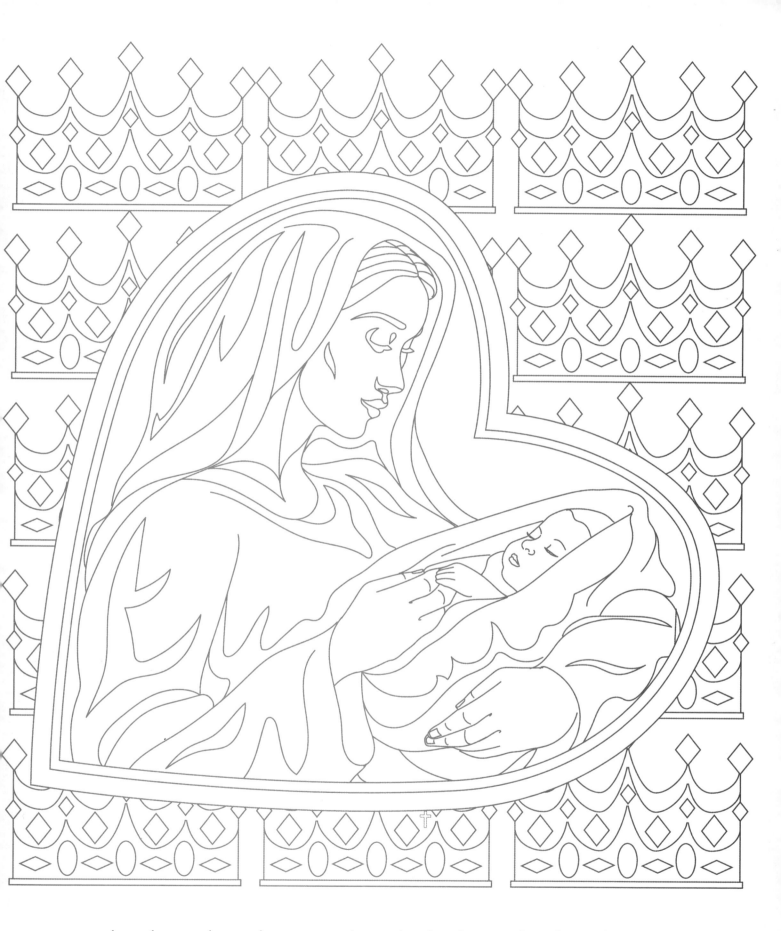

This, this is Christ the King, Whom shepherds guard and angels sing.
"What Child is This?"

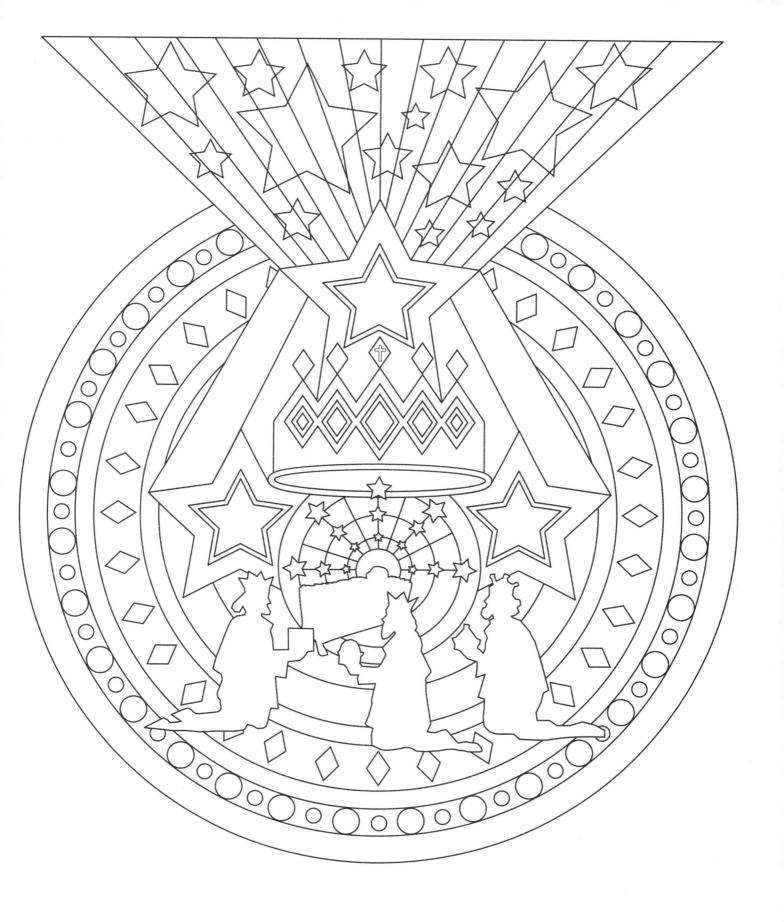

Come adore on bended knee, Christ the Lord, the newborn King.

"Angels We Have Heard on High"

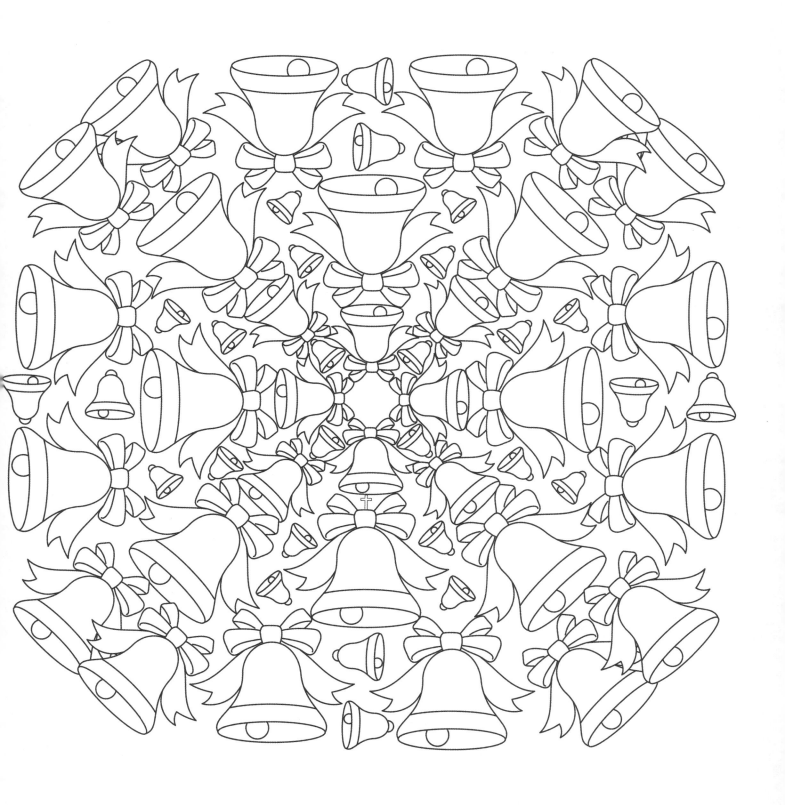

Then pealed the bells more loud and deep: "God is not dead, nor doth He sleep;
The wrong shall fail, the right prevail, With peace on earth, good will to men."

"I Heard the Bells on Christmas Day"

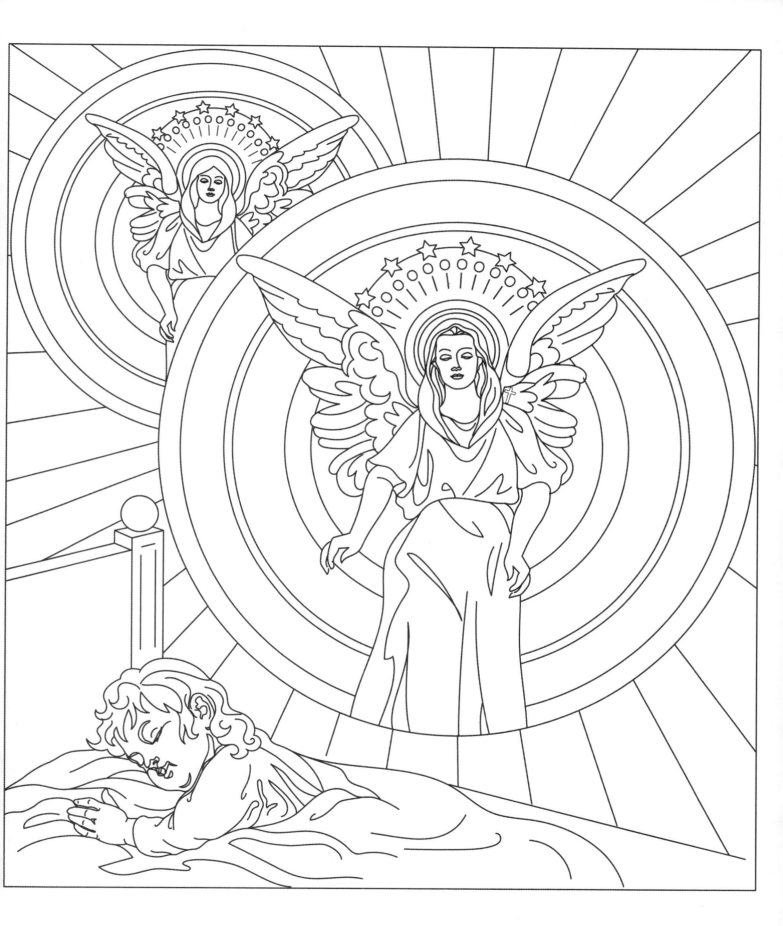

While mortals sleep, the angels keep Their watch of wondering love...
"O Little Town of Bethlehem"

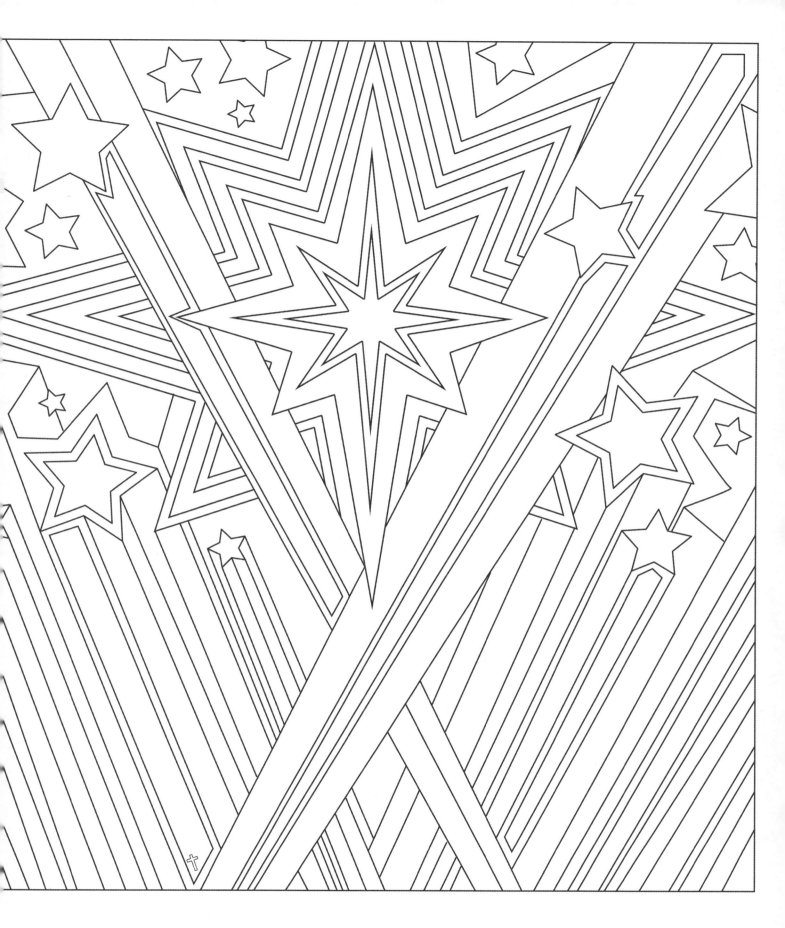

They looked up and saw a star, Shining in the East beyond them far...
"The First Noel"

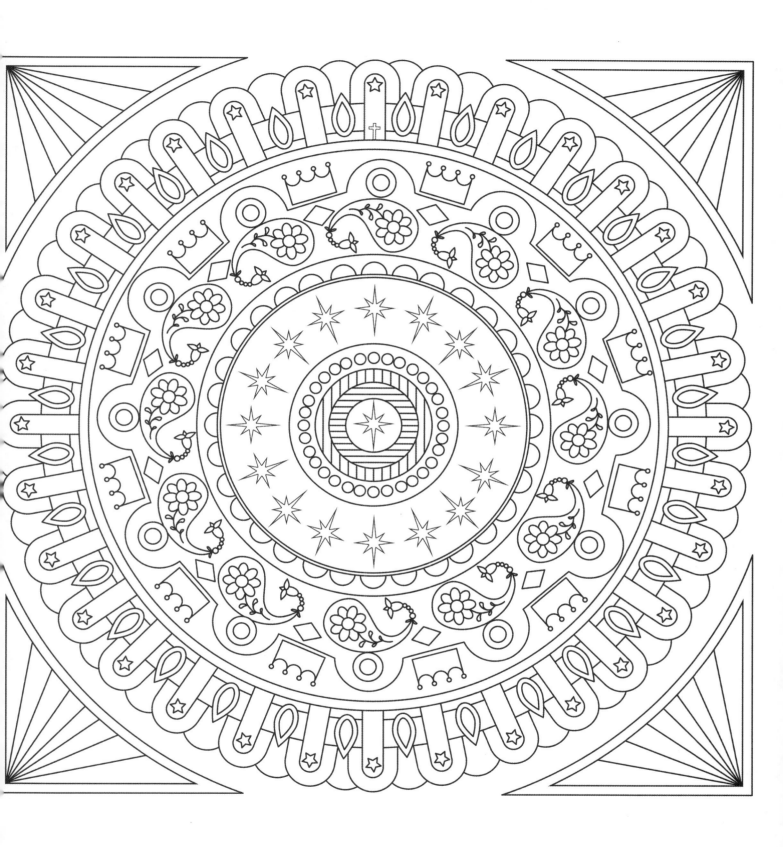

For unto you is born this day in the city of David a Saviour, which is Christ the Lord.
Luke 2:11

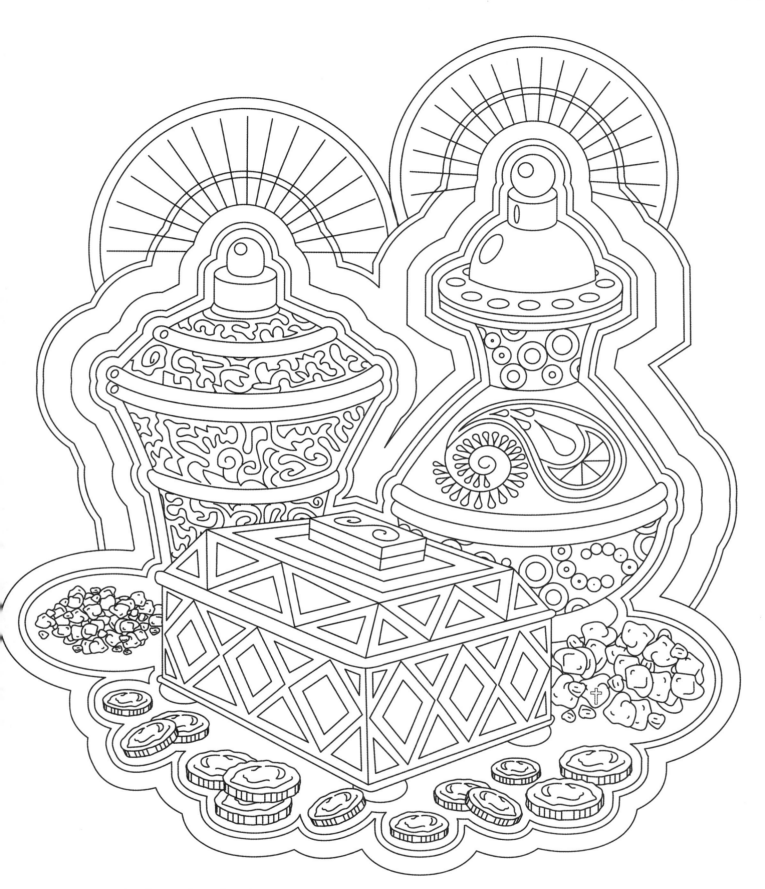

And when they had opened their treasures, they presented gifts to Him:
gold, frankincense, and myrrh.

Matthew 2:11

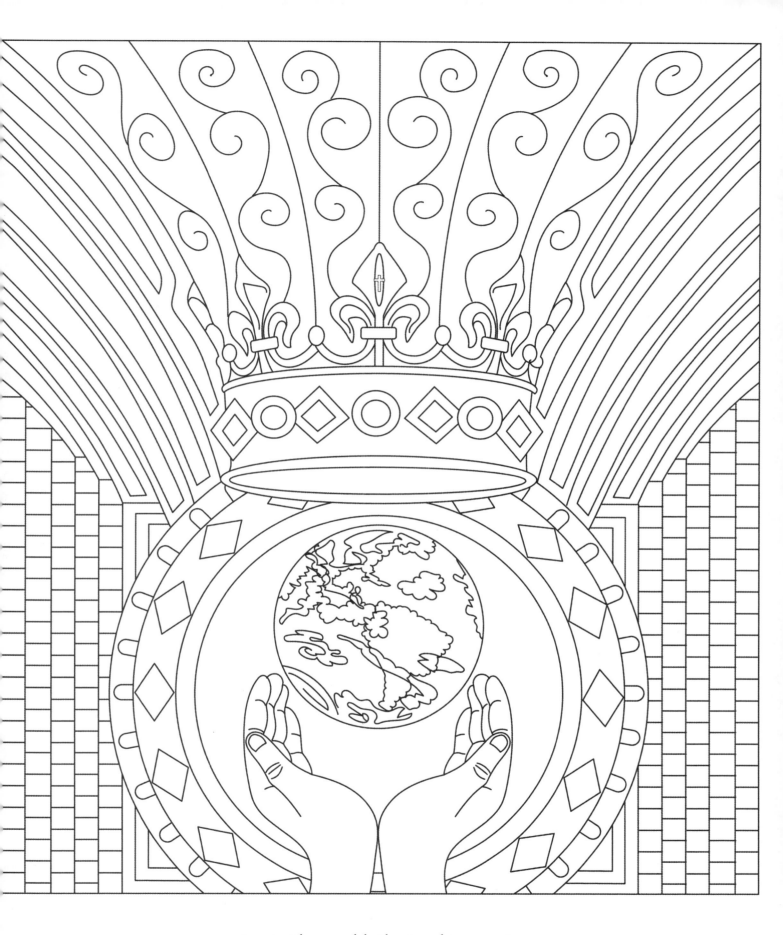

Joy to the world, the Lord is come!
"Joy to the World"

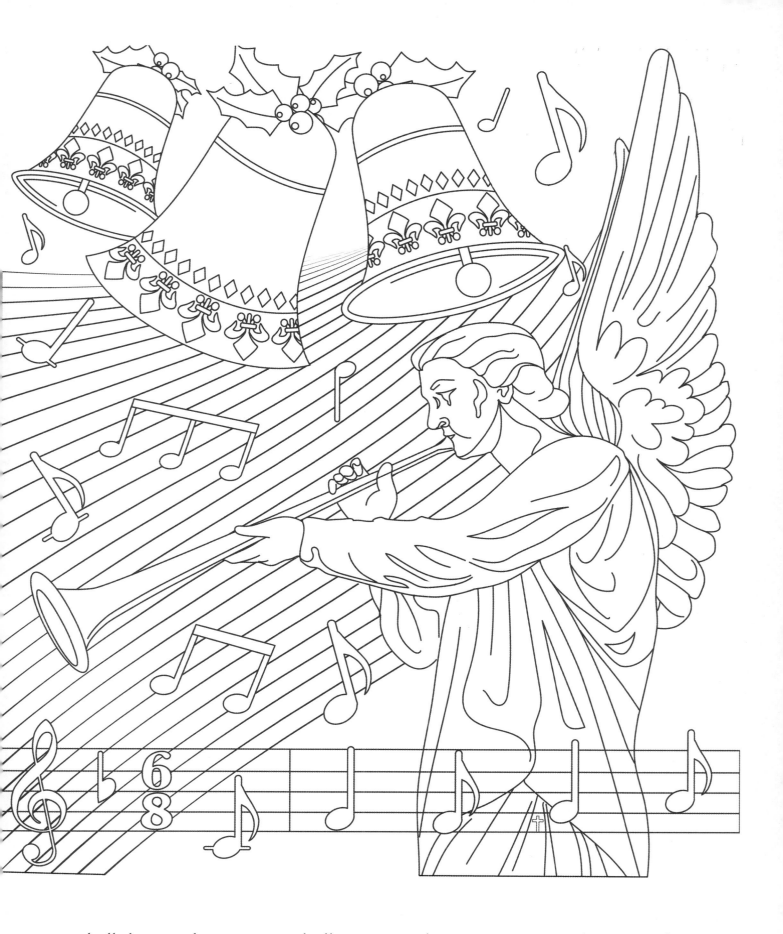

And all the Angels in Heaven shall sing. On Christmas Day, on Christmas day;
"I Saw Three Ships (Come Sailing In)"

Peace on earth, and mercy mild, God and sinners reconciled.

"Hark! The Herald Angels Sing"

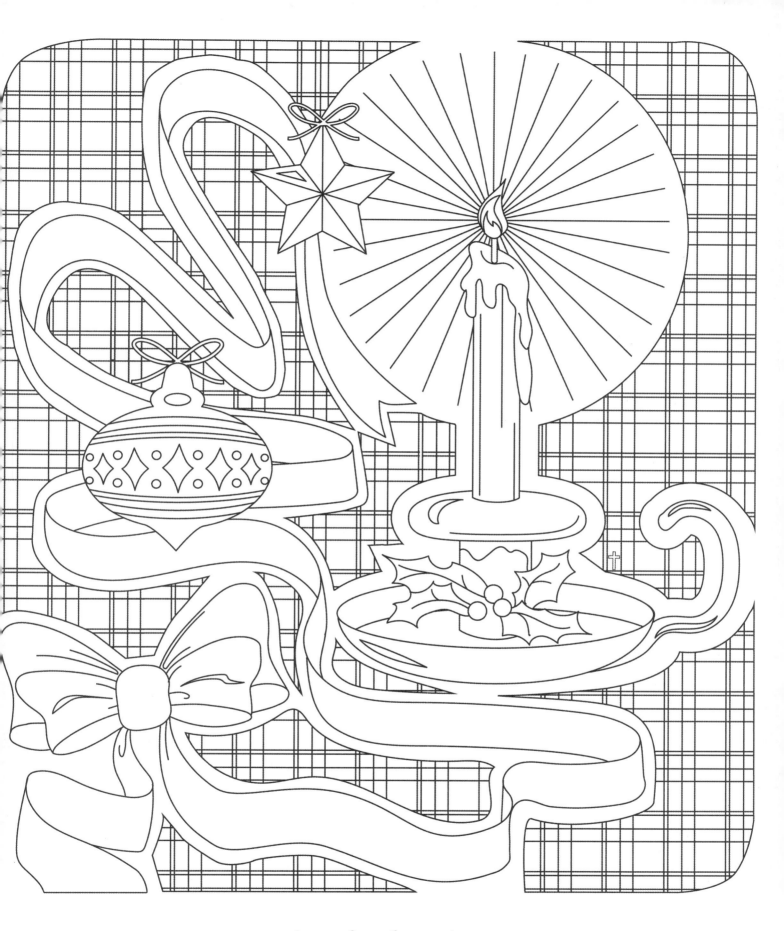

O tidings of comfort and joy...
"God Rest Ye Merry Gentlemen"

...and glory shone around...
"While Shepherds Watched Their Flocks"

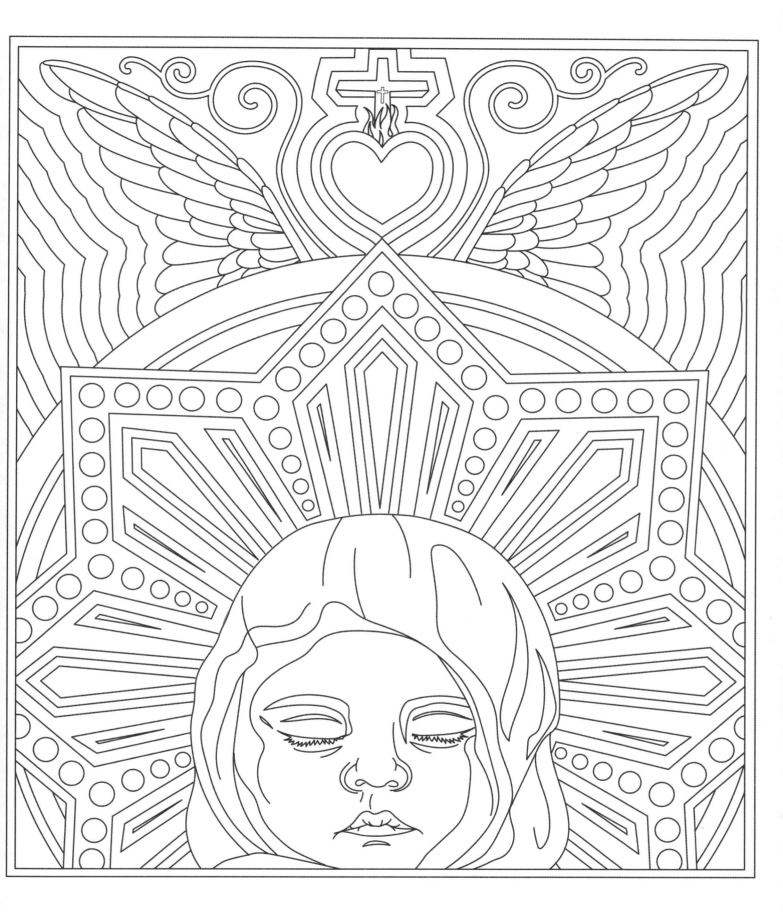

"What child is this, who, laid to rest on Mary's lap, is sleeping?"

"What Child is This?"

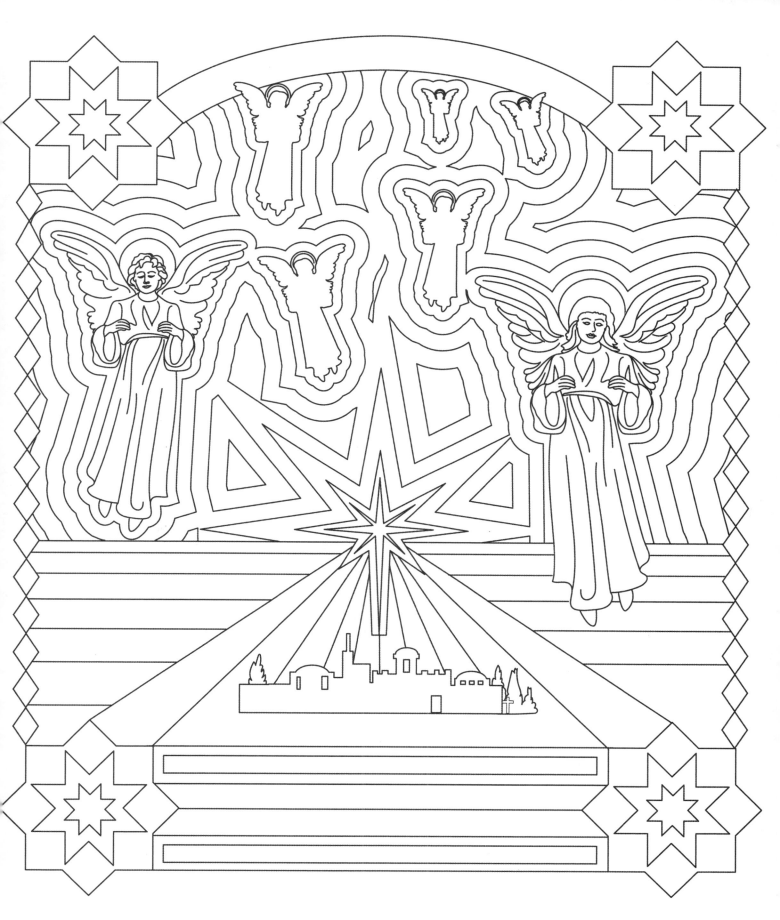

The world in solemn stillness lay, To hear the angels sing.
"It Came Upon the Midnight Clear"

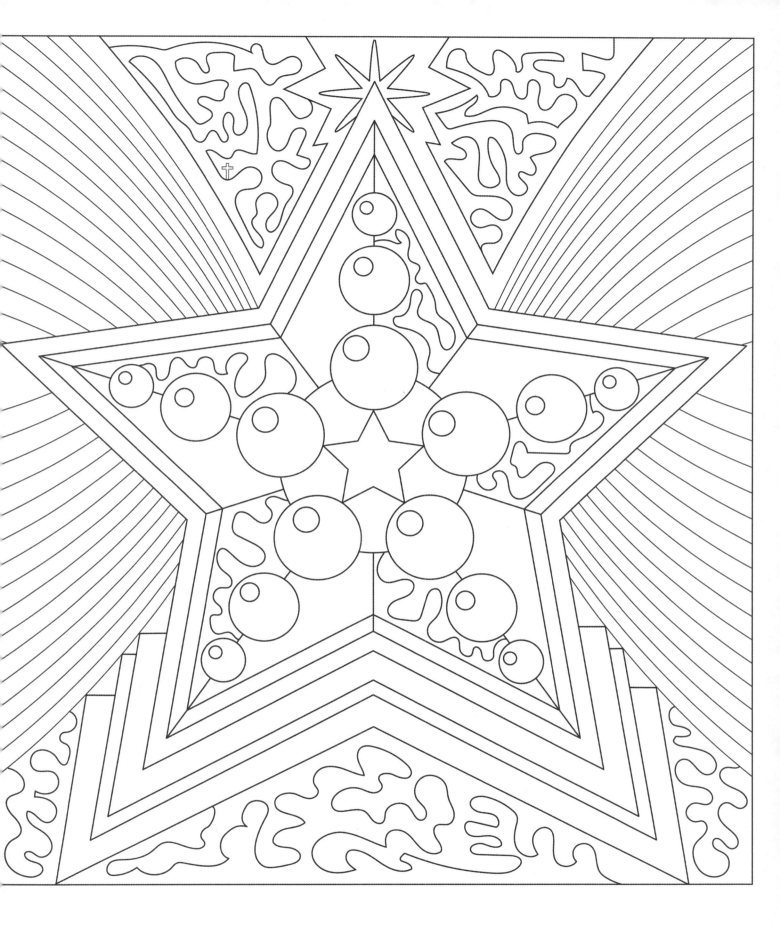

O Star of wonder, star of night, Star with royal beauty bright...
"We Three Kings"

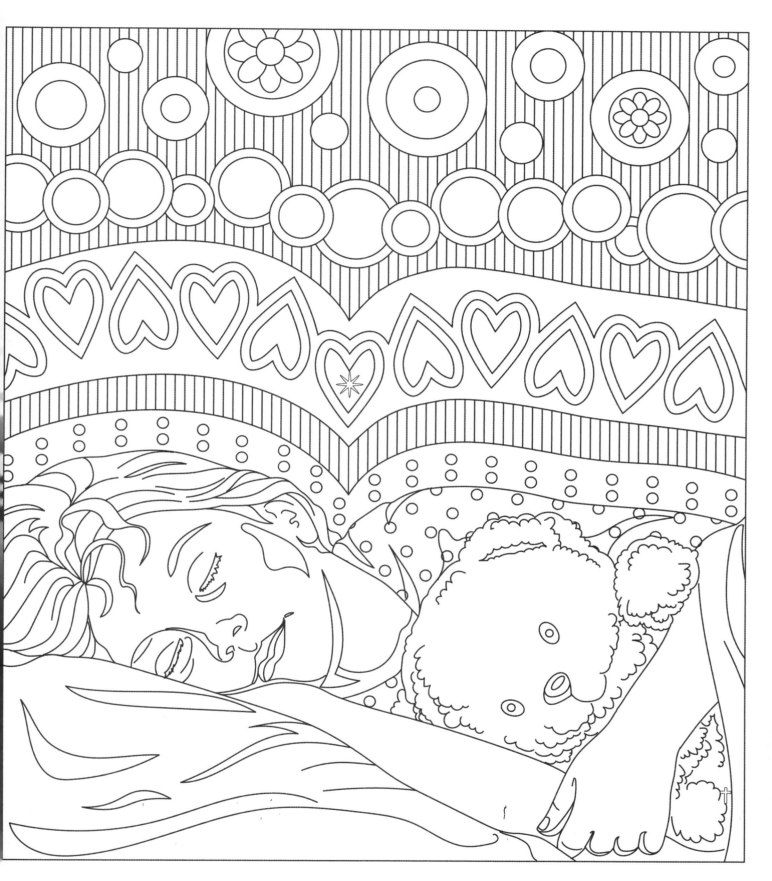

Be near me, Lord Jesus, I ask Thee to stay,
Close by me forever, And love me, I pray...
"Away in a Manger"

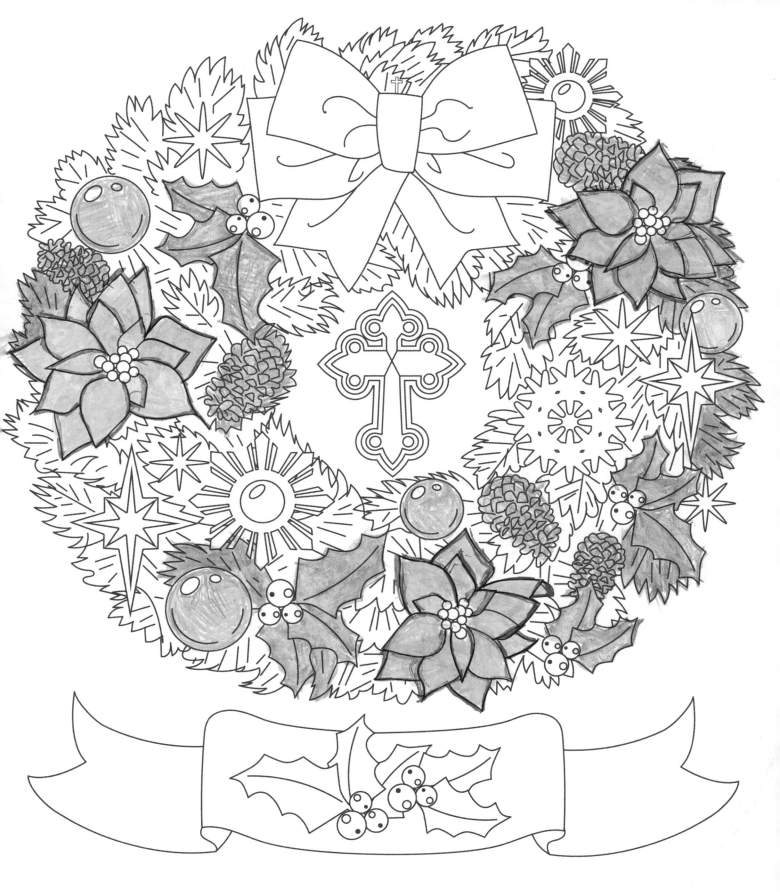

Good tidings we bring to you and your kin,
Good tidings for Christmas and a Happy New Year.
"We Wish You a Merry Christmas"

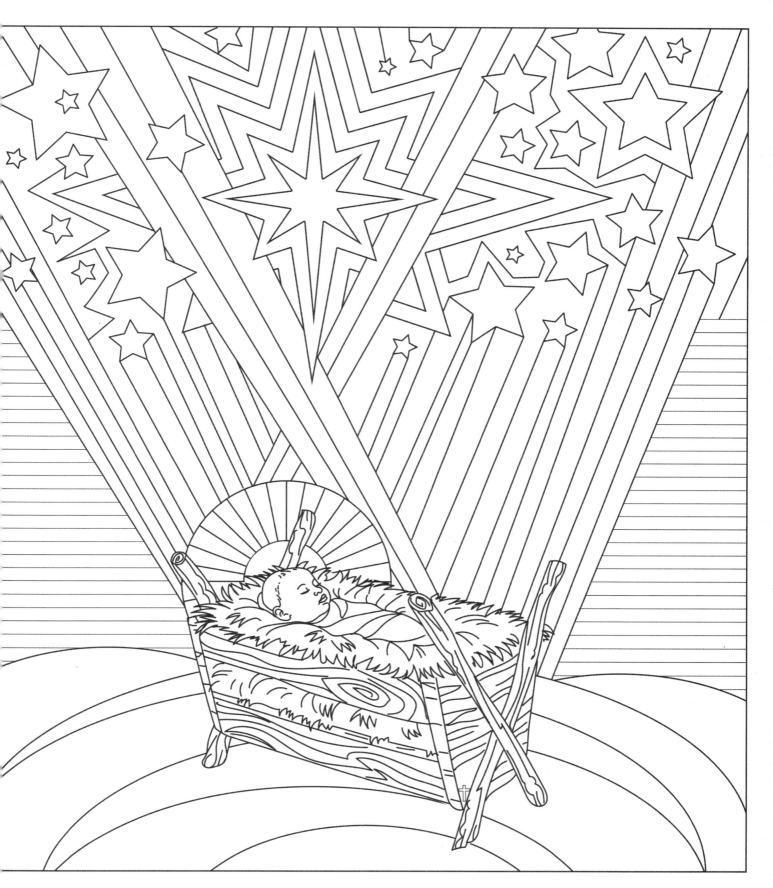

*The stars in the bright sky looked down where He lay,
The little lord Jesus asleep on the hay.*

"Away in a Manger"